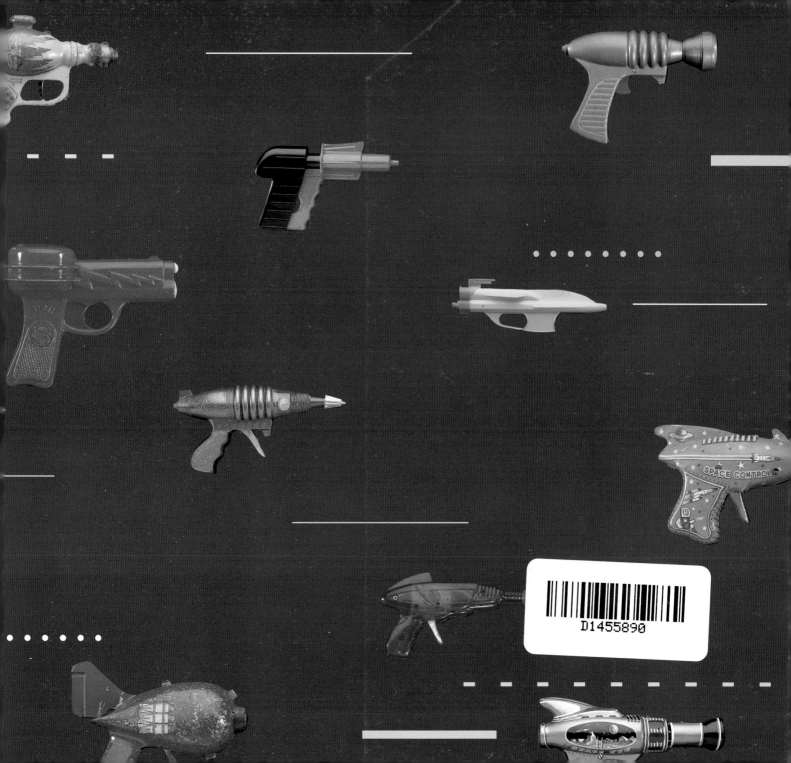

DEDICATION

To the memory of my father, Louis Singer,
who gently passed his fascination with the
future on to me—and to my children, Hannah
*and Noah, who **are** the future.*

Library of Congress Cataloging-in-
Publication Data

ISBN: 0 8118 0033 4
Singer Leslie
Zap! Ray Gun Classics/Leslie Singer.
p. cm.
1. Toy pistols—Collectors and collecting 1. Title.
TS532.4.S56 1991
688.7'2—dc20
91-8898
CIP

Design: Karen Smidth

Distributed in Canada by
Raincoast Books,
112 East Third Avenue, Vancouver,
B.C. V5T 1C8

10 9 8 7 6 5 4 3 2 1

Chronicle Books
275 Fifth Street, San Francisco
California 94103

ZAP!

RAY GUN
CLASSICS

Chronicle Books . San Francisco

LESLIE
SINGER

ABOUT
THIS BOOK

This book is about the power of design and imagination. I do not present it as a comprehensive guide to collectible ray guns but simply as an overview of my collection and pieces of other collections, where noted. The amount of information for each toy varies with my resources and the markings on the toys themselves. The reason that some beautiful and classic ray guns are not included is that I do not currently own them and could not borrow them in time for publication. But you can have a great time searching for your own treasures or looking at them in some of the many wonderful and scholarly books available on the subject. I've listed a few in the bibliography.

Some collectors move away from toys that are not in mint condition. I move toward them. For me, a toy that has been played with has had life breathed into it—like a beautiful, broken-in baseball glove. The scratches, scuffs, and dents are proof that its purpose in life has been fulfilled.

PRICE GUIDELINES

Prices are listed in this book according to the author's experience and are for information purposes only.
Prices will vary with demand, condition, locale, knowledge, desire of the buyer and seller, and other factors.
Buying and selling are at the reader's risk and neither the author nor publisher shall be held responsible
for losses that may occur through use of this book in the buying or selling of any items, or due
to typographic or other errors.

A book is like a concert. It takes a lot of people working together, on and off the stage, to make something happen. I owe a tremendous debt of thanks to my fellow collectors and friends who so generously contributed their weapons, time, and knowledge.

I would especially like to thank Tom E. Tumbusch, who helped in many ways despite his own very busy publication and toy show schedule. His book Illustrated Radio Premium Catalog and Price Guide, *and another by his son, T.N. Tumbusch,* Space Adventure Collectibles, *are among my very favorites. Special thanks also to Norm and Cathy Vigue for sending me part of their fine collection on nothing more than a phone call. There still is faith and honor in the world. Gratitude also to Grant Irwin, Thomas H. Burgess, James Elkind, and my good friends Rick and Sara Armellini for supplying me with their knowledge and toys.*

A standing ovation to my photographer, Dixie Knight, who rocked around the clock to finish this project and always had a good time doing it. Special applause to my copy editor, Carey Charlesworth, for her humbling and exacting expertise. And a double-stroke drum roll to the band at Chronicle Books for their enthusiasm, advice, and skills: Nion McEvoy, Mary Ann Gilderbloom, Lisa Howard, Karen Pike, and Charlotte Stone. Another Chronicle book, Past Joys, *by Ken Botto, was the first toy book I ever had. It's a thrill to be doing one of their latest.*

Big hugs and kisses to my wife, Connie, for her love and support. And to my beautiful children, Hannah and Noah, who still share a bedroom so that Daddy can keep his toy room intact for a little while longer.

Love and gratitude beyond words to my mother, Dorothy Singer. She, along with my late father, Louis, and sister, Sandi, created the happiest of childhoods for me to treasure.

And finally to all the toy designers and manufacturers, especially those in Battle Creek, Michigan, eternal source of cereal box premiums, and of course to the space heroes and heroines of stage, screen, radio, television, comics, and books, and all who helped bring them to life . . . thank you.

It's been a blast.

BACK ON CURLEY STREET

During the 1950s, the exact address of my universe was 9 Curley Street, Long Beach, New York. This was the house of my best friend and fellow Space Cadet, Jeffrey Adler. From his basement bedroom a thousand rocket missions were launched, with Jeffrey and me as copilots on every one of them.

Although we traveled toward the unknown, our adventures always had the same comforting plot: we would conduct our daily space cabin business—adjusting the phono— . . . uh, gravity dials—and scanning the stars through toilet paper telescope tubes. One of us—we'd take turns—would inevitably step near a porthole window, then suddenly slump over in a heap. The other would rush to his aid. "Commander . . . are you okay ?" Slowly, the fallen copilot would rise and brush himself off. "I'm fine," he'd say, more deliberately than normal. "I must've blacked out, or . . ." WHAM! Before you could say "Holy asteroid belt," my fellow cadet would have me in a neck-wrenching headlock.

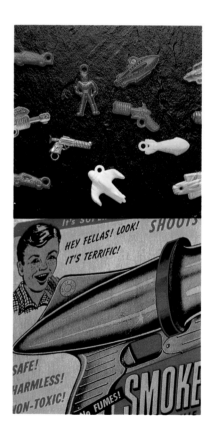

For those of you too young, old, or wimpy to know it, the headlock was the immobilization technique of the fifties. A guy (or girl) who knew how to throw a good headlock on you could walk through any playground fearless and feared at the same time. "Karate" wasn't an American word yet—although there was something called a rabbit punch that was always targeted to the back of the neck and hurt like hell for hours. But I digress.

Back in the headlock, the situation was immediately understood. Jeffrey had been struck, yet again, by an enemy ray. It always happened when one of us went too close to that porthole.

The effect of an enemy ray is as quick as it is contemptible. It simply makes instant enemies out of lifelong friends. This gave Ming the Merciless or other villains a chance to sabotage our mission. It also gave Jeffrey and me a reason to wrestle for—and I kid you not—at least three hours at a time.

And that's where this book really begins. Because at some point in our titanic struggles, actually, at many points in our struggles, there would be opportunities for each of us to lunge for one of the dozen or more ray guns stashed around the "cabin."

Zapping your copilot under these circumstances was totally acceptable, especially since almost all ray guns had an intensity setting. This allowed you to simply stun your opponent until he came to his senses. Or you might just "freeze" him in midstrike; jolt him with a mild electromagnetic charge; or make yourself invisible so that you could get him in a headlock. (You could also create the opportunity for any of these by stopping time.) You might choose to drench him in the enemy-ray antidote, "friendly acid." But my personal favorite was simply to put him to sleep temporarily with a puff of ionized baking powder from my bright red Space Patrol Cosmic Smoke Gun.

Don't be fooled. Complete nuclear vaporization was just a finger flick away. But this was the fifties; times were gentler then. Not that you'd know it from the look and feel of the ray guns.

Back in the the early thirties, when beautiful ray guns like the Buck Rogers XZ-31 Rocket Pistol and the XZ-38 Disintegrator Pistol were

introduced, they came with more than shiny heft, sparks, and pops. They carried with them that uniquely optimistic design that characterized other Art Deco works of the period. This same outlook was reflected in the Raymond Lowey look of the fifties. And how understandable that was!

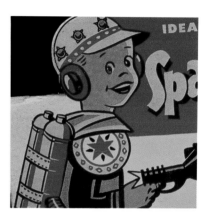

During the post-Depression thirties, and again in the mid-fifties, "future" was synonymous with optimism. Perhaps it's difficult to recall today, but back then, the future was actually something to look forward to. It held unlimited, fantasylike promise. In spite of the nuclear presence, the nation's outlook, economy, technological superiority, and pride reached for the sky.

Which brings me back to guns.

If these periods held the promise of power, toy ray guns magnified that power exponentially. After all, to a kid even an old-fashioned six-shooter was unstoppable. But a ray gun that could shoot invisible beams across a galaxy, well, that was another dimension entirely.

The fantastic colors. The surreal shapes. The adventures of the comic book and television heroes themselves unfettered by the constraints of earthly physics. This was imagination plus. How lucky I feel to have lived it . . . and to carry the memories and excitement still so close to the surface.

When I attend some of the hundreds of antique toy shows held each year, I dream about my happy childhood for days afterward. Seeing all the old,

familiar hues, the forms and characters, fires the old neurons in a most profound way. When I expect a new toy to arrive at my house by mail, I'm right back on Curley Street again, waiting for the postman to hand me my latest treasure from Battle Creek, Michigan.

It's a joy for me to present these icons that somehow capture the past, present, and future all in one beautiful instant. I hope you enjoy them, too.

Leslie Singer
January, 1991

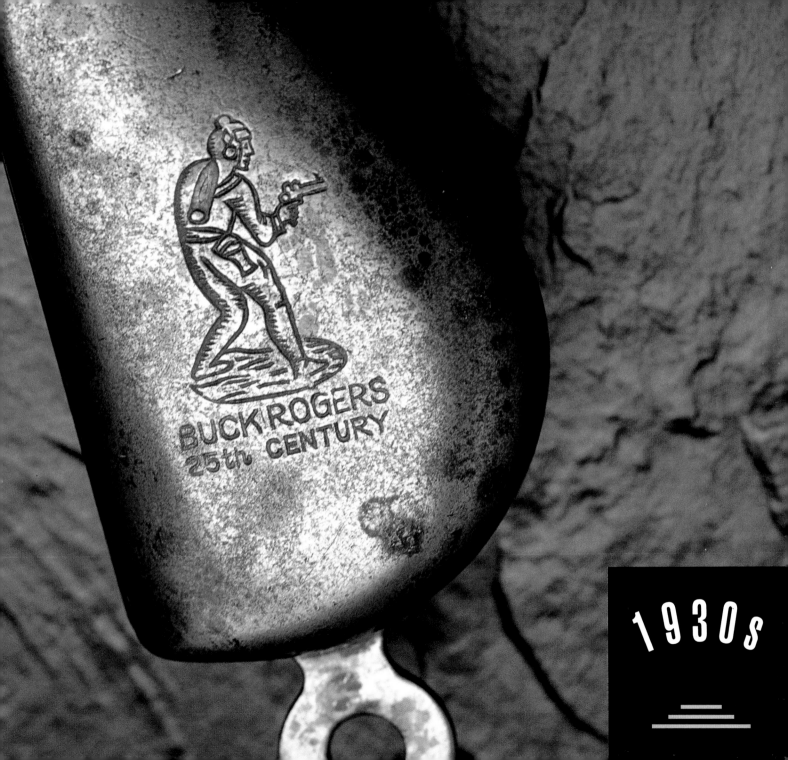

BUCK ROGERS
25th CENTURY

1930s

1

Remnant of an ancient
Buck Rogers Disintegrator
1930s

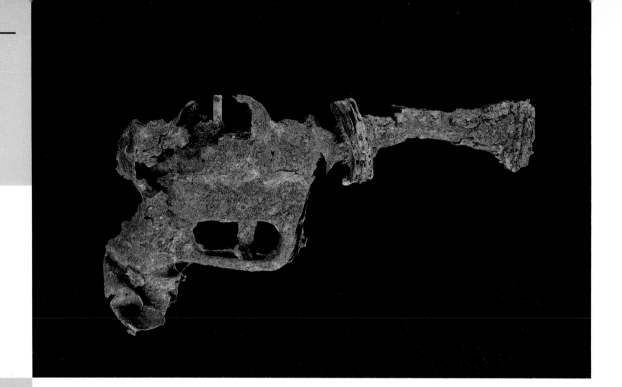

2

Rocket Signal Pistol;
no markings
1930s

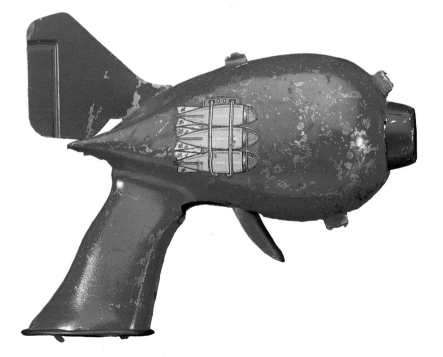

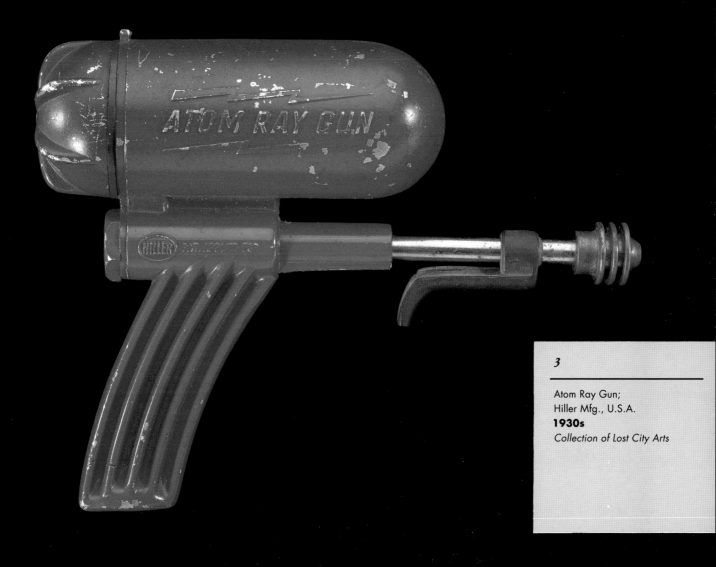

3

Atom Ray Gun;
Hiller Mfg., U.S.A.
1930s
Collection of Lost City Arts

4

Buck Rogers cast-iron rocket
1930s

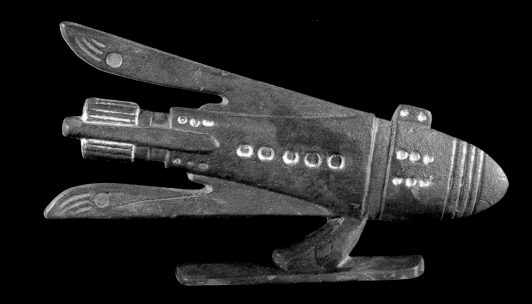

5

Lead figures: spacemen,
cast-iron space ship,
Buck Rogers
1930s

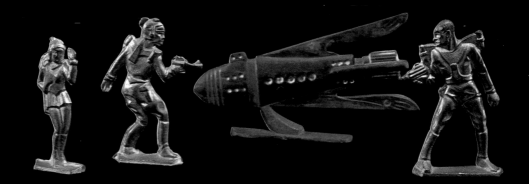

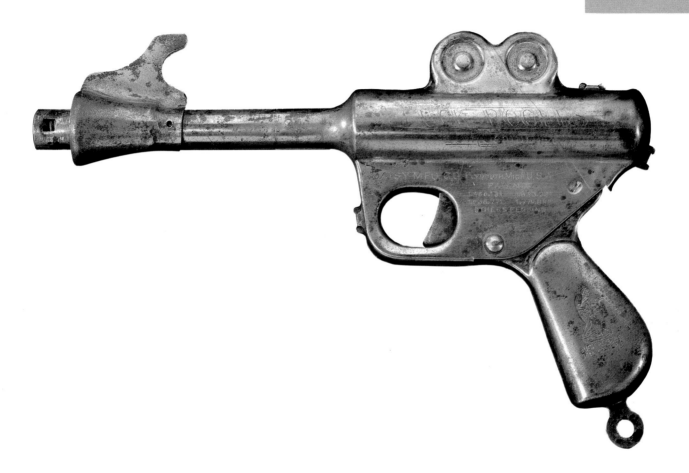

Pop Ray; All Metal Products Co.,
Wyandotte, MI
1930s

8

Buck Rogers XZ-44
Liquid Helium Water Pistol;
Daisy Mfg., Plymouth, MI
1936
(This gun also came in
a copper finish.)

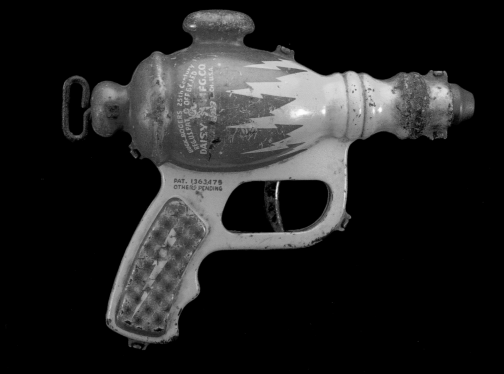

Buck Rogers XZ-38
Disintegrator Pistol; Daisy Mfg.,
Plymouth, MI
1936
*One of the true classics. A flint in
the top made a spark that showed
through the "electronic compression
viewplate" as it popped. A holster
was sold separately.*

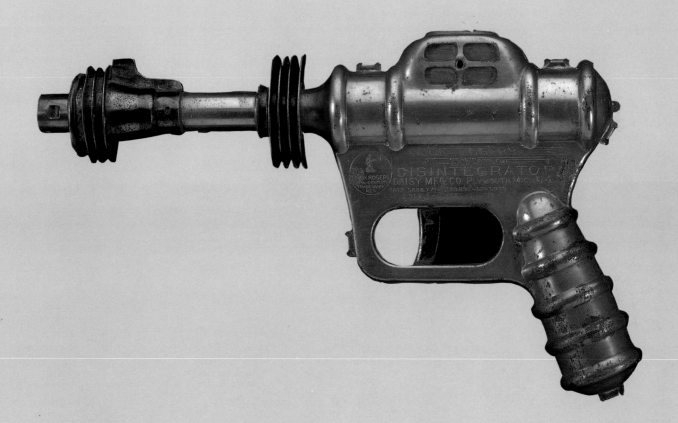

Buck Rogers ad card
1936
*Collection of Norm and
Cathy Vigue*

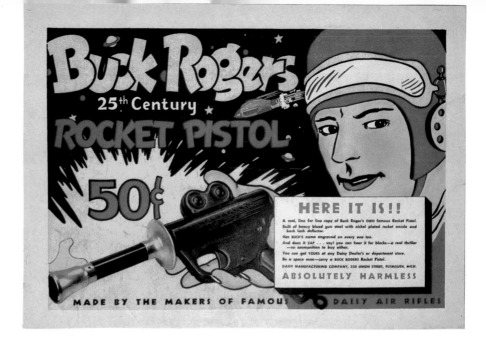

Nu-Matic paper popper;
U.S.A.
1936

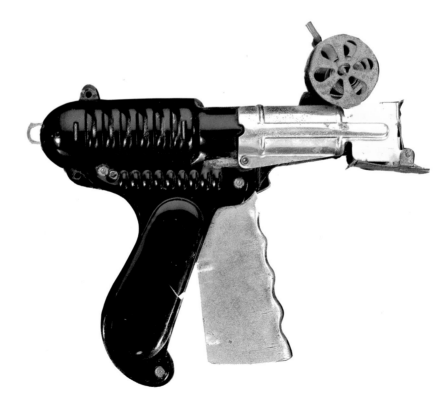

"Buck Rogers" Sunday
funnies; *The Denver Post,*
July 2, 1933

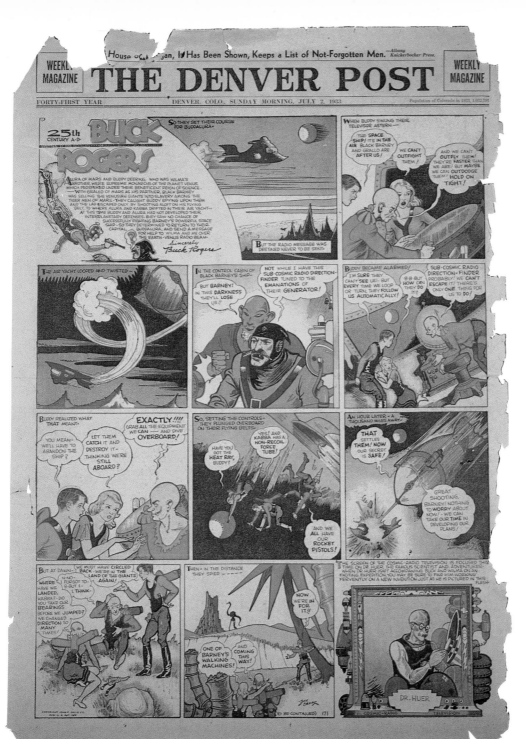

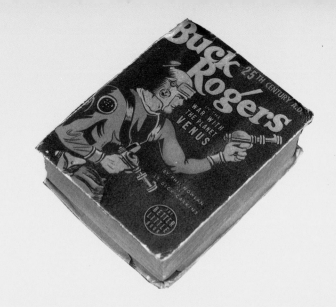

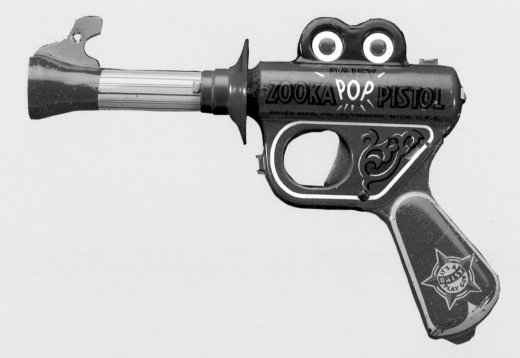

Paper popper; no markings
1930s-40s

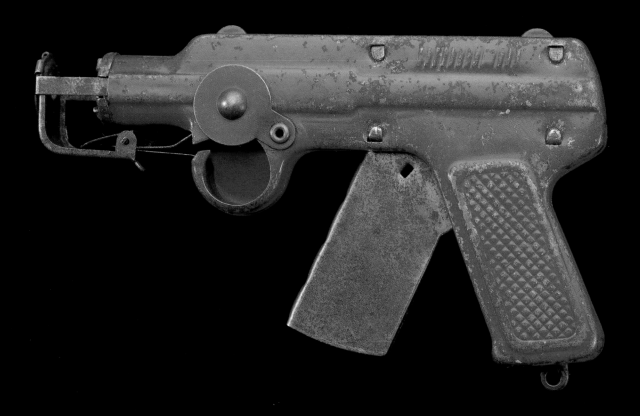

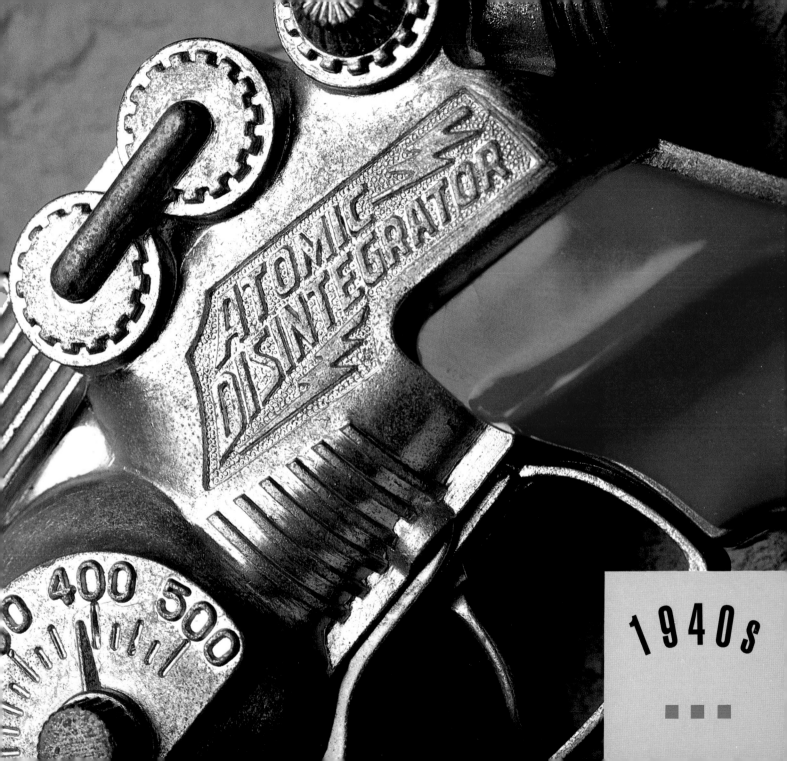

ATOMIC DISINTEGRATOR

400 500

1940s

Flash Gordon Air-Ray
Blaster cocked
1940s

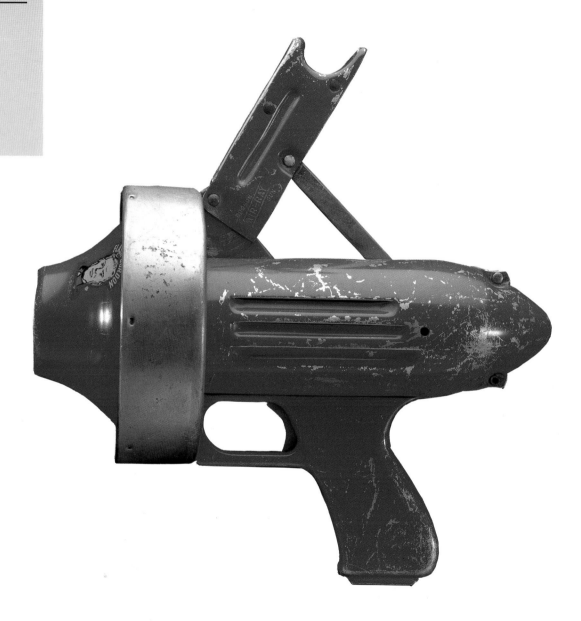

Rocket Dart Pistol;
Daisy Mfg., Plymouth, MI
1940s

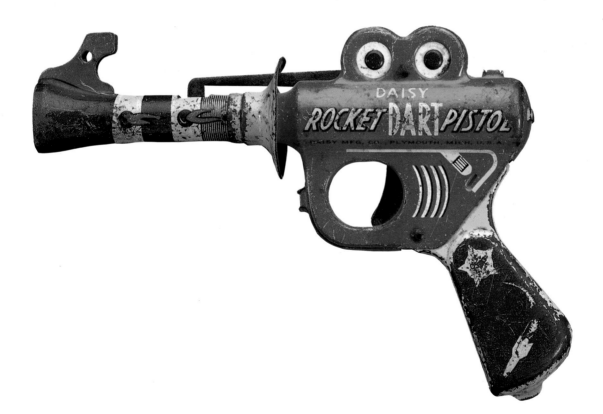

Atomic Disintegrator
repeating cap pistol;
Hubley Mfg., Lancaster, PA
1940s
*One of the most beautiful ray
guns ever made.*

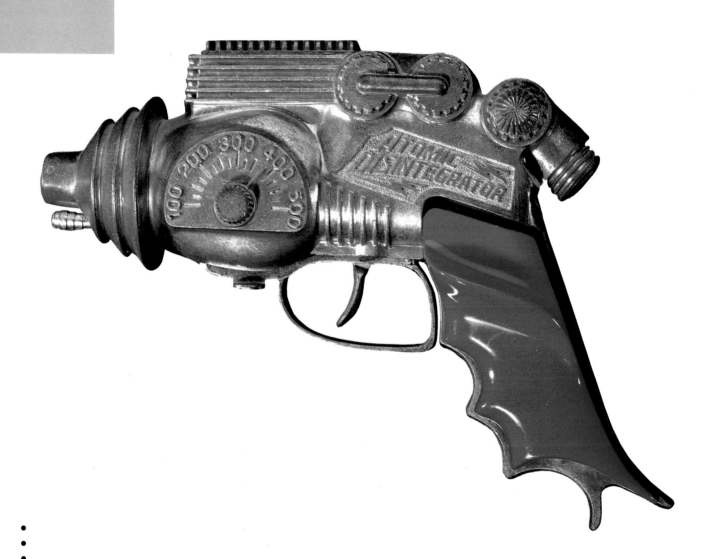

Atom Bubble Gun; U.S.A.
1940s
*Collection of Rick and Sara
Armellini*

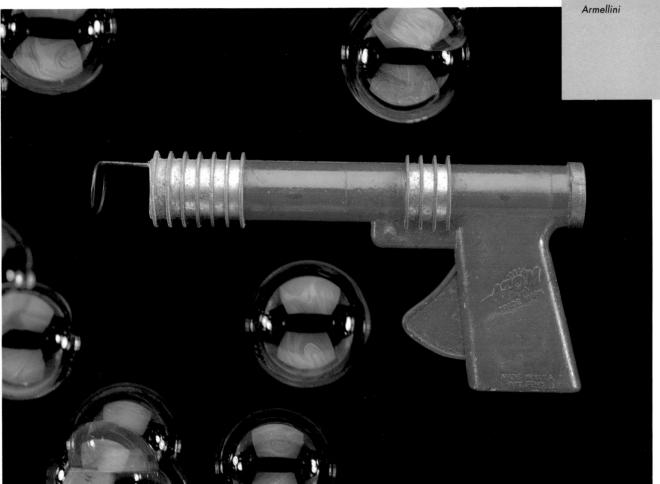

20

Smoke Ring Gun; Nu-Age Products Creations, Beverly Hills, CA
1940s-50s
Sold with special matches shaped like rockets that would fill the chamber with smoke when the gun was cocked. An air bladder then blew perfect smoke rings out the barrel.

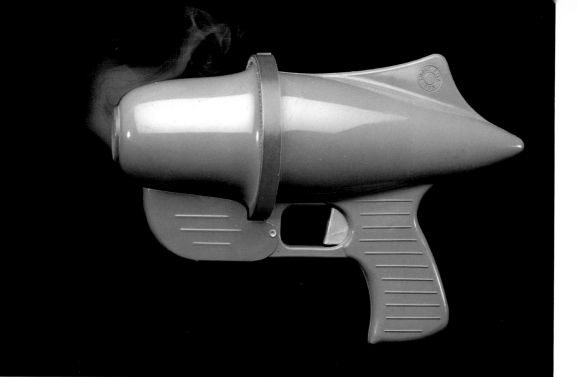

21

Detail: smoke matches for Smoke Ring Gun

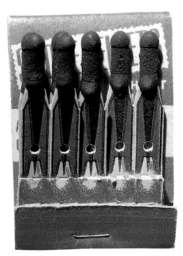

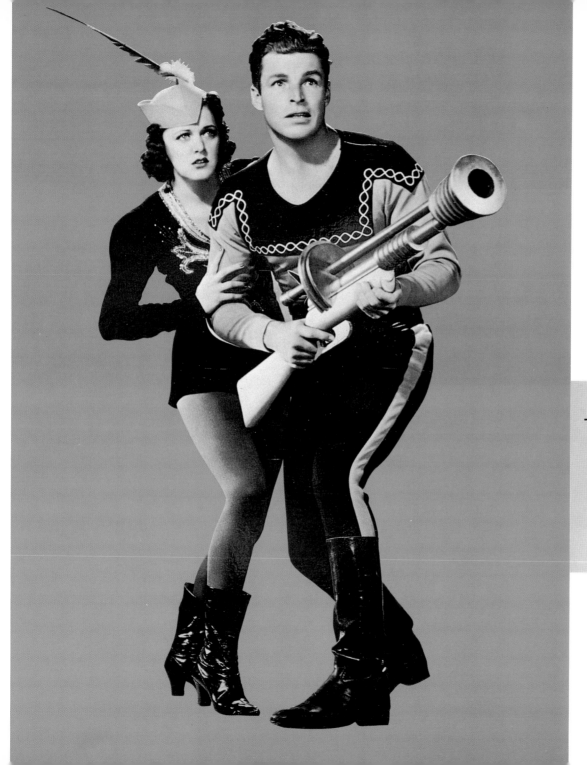

Buster Crabbe
and Jean Rogers as
Flash Gordon
and Dale Arden
Circa 1937

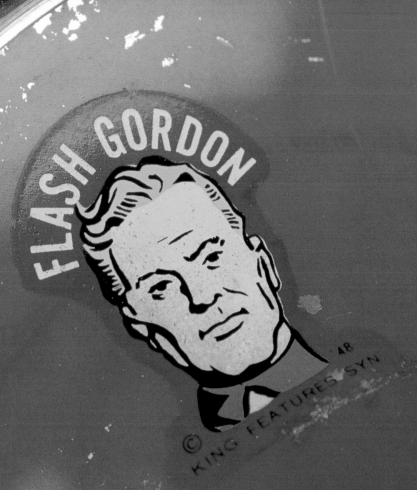

FLASH GORDON

© KING FEATURES SYN 48

1950s

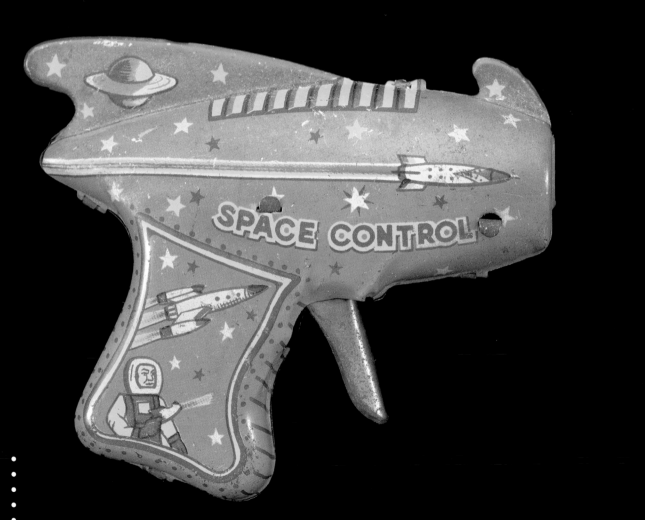

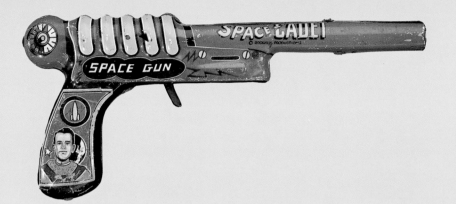

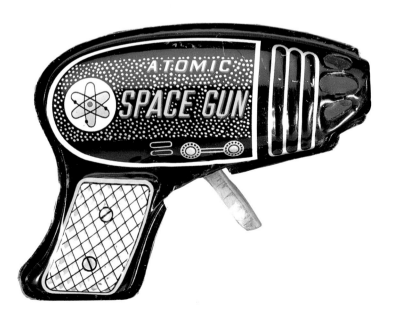

Space Patrol Rocket
Gun box
1950s

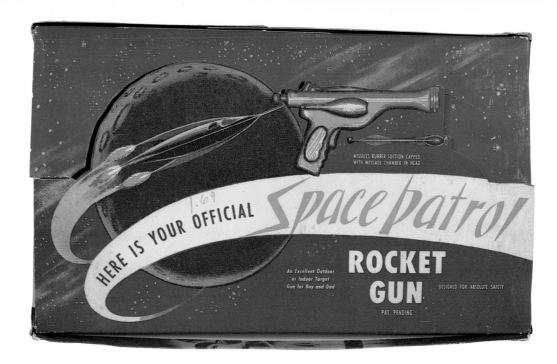

27

Space Patrol Rocket Gun;
U.S. Plastic Co., Pasadena, CA
1951
*Collection of Norm and
Cathy Vigue*

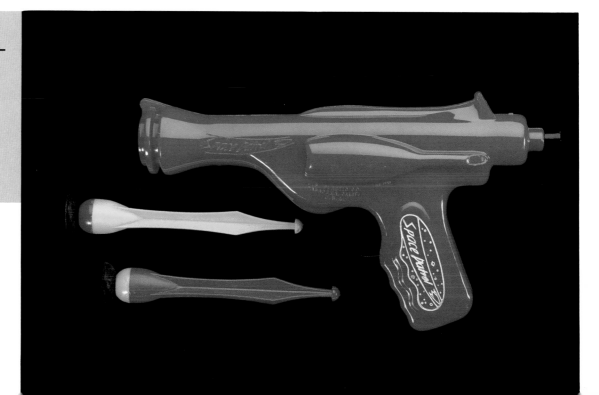

Atomic Flash; J. Chein & Co.,
U.S.A.
1950s
*Collection of Rick and
Sara Armellini*

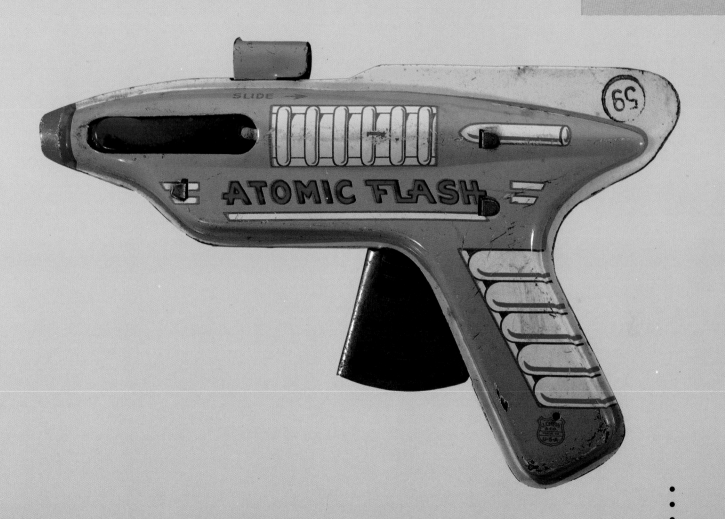

Tom Corbett Push-Out
Book; The Saalfield
Publishing Co., Akron, OH
1952

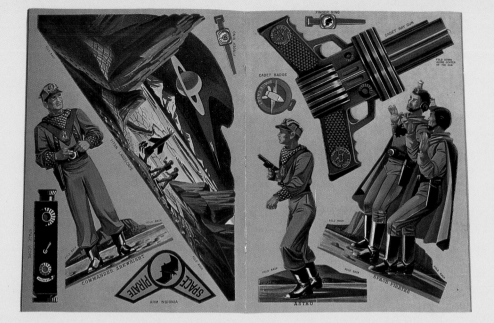

Space Patrol Cosmic
Smoke Gun
1950s
*Also available in green
with a longer barrel.
Both shot baking soda that was
supposed to put your partner
to sleep. My personal all-time
favorite.*

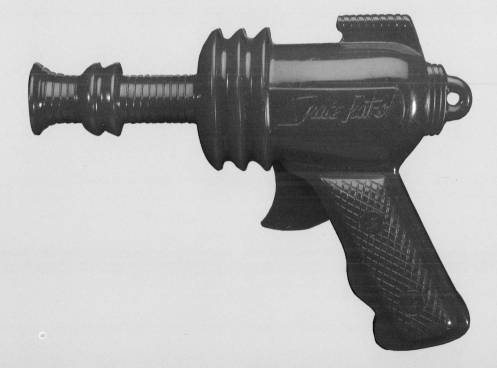

Red clicker; no markings
1950s

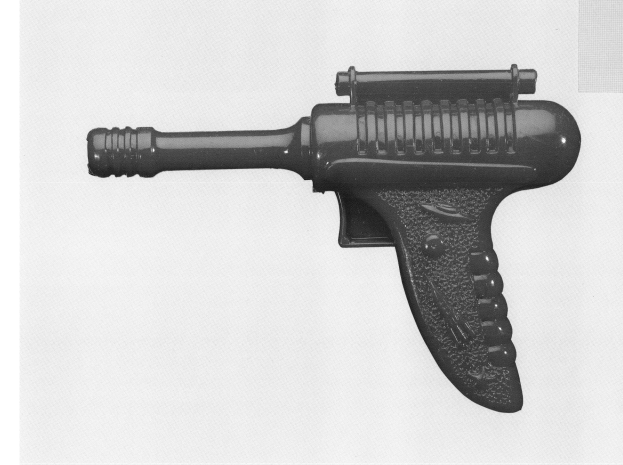

Flash Gordon Click Ray
Pistol box
1950s

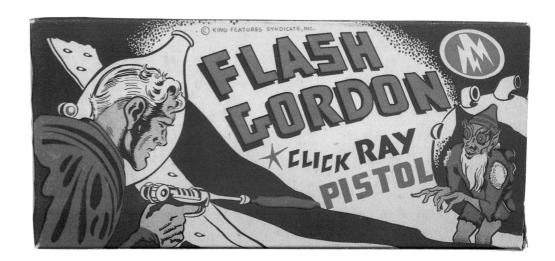

Red water pistol;
Palmer Mfg., U.S.A.
1950s

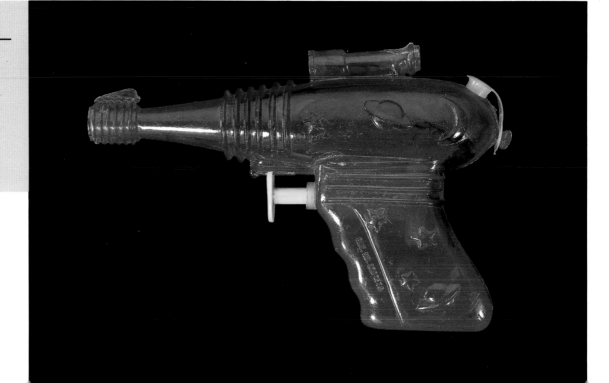

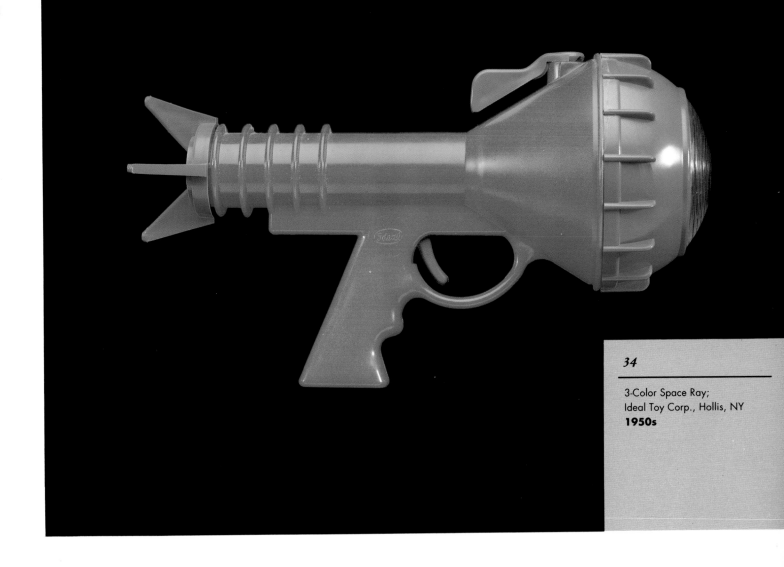

34

3-Color Space Ray;
Ideal Toy Corp., Hollis, NY
1950s

35

Rex Mars Planet Patrol
Sparking Pistol; Marx,
New York, NY
1950s

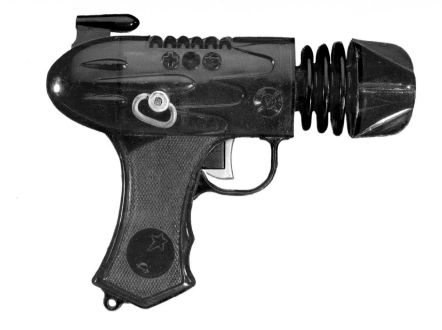

36

Sonic Squirt; marked "K,"
U.S.A.
1950s
*Collection of Rick and
Sara Armellini*

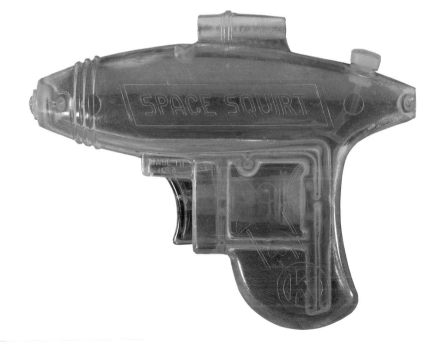

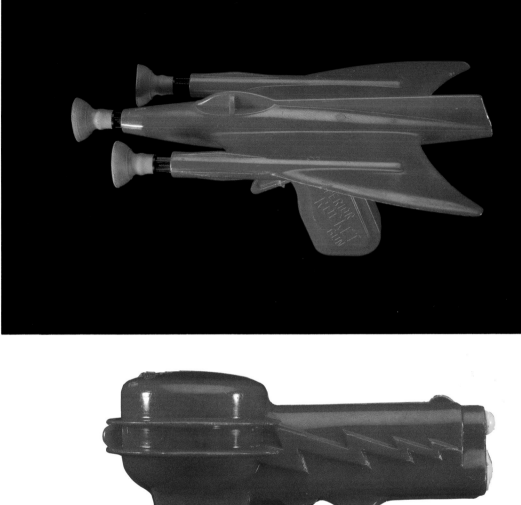

Rocket Gun;
Superior Mfg. Co., U.S.A.
1950s
*Collection of Rick and
Sara Armellini*

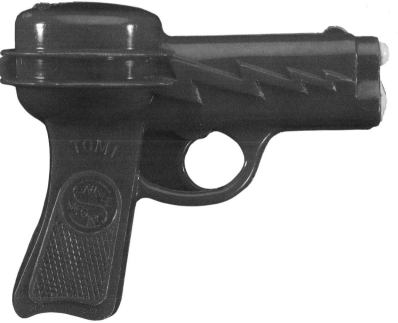

38

Tomi gun;
Shawnee Mfg. Co., U.S.A.
1950s
*Collection of Rick and Sara
Armellini*

Planet Jet; Renewal Mfg,
U.S.A.
1950s
*Collection of Rick and
Sara Armellini*

40

Tom Corbett Atomic Rifle;
Marx, New York, NY
1950s
Collection of Tom E. Tumbusch

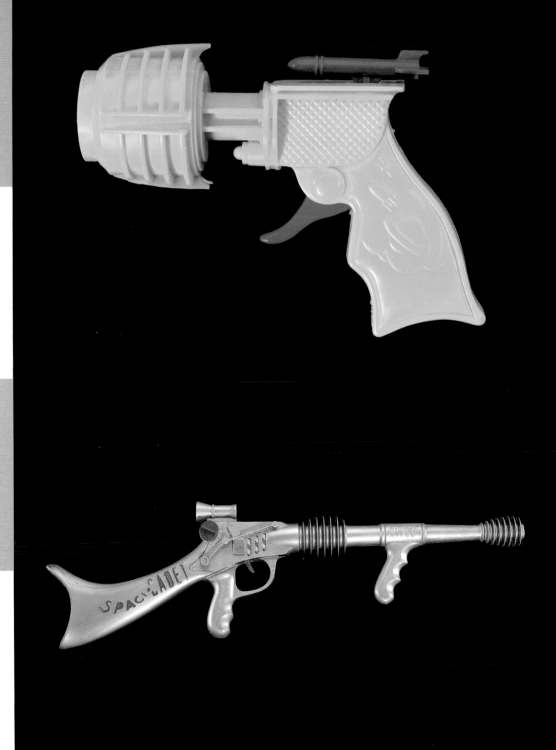

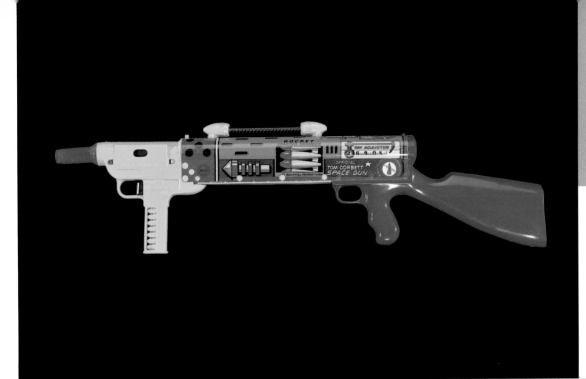

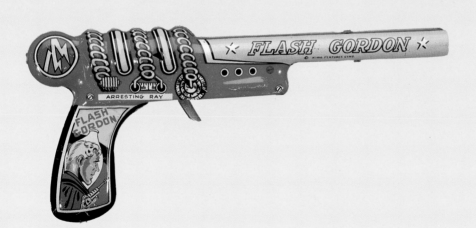

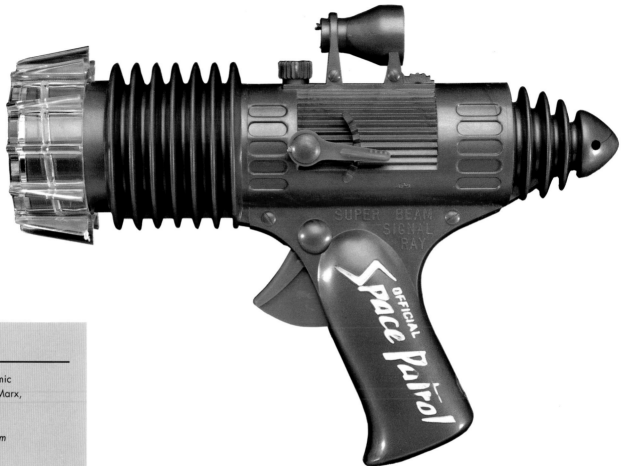

43

Space Patrol Atomic
Flashlight Pistol; Marx,
New York, NY
1950s
*Collection of Norm
and Cathy Vigue*

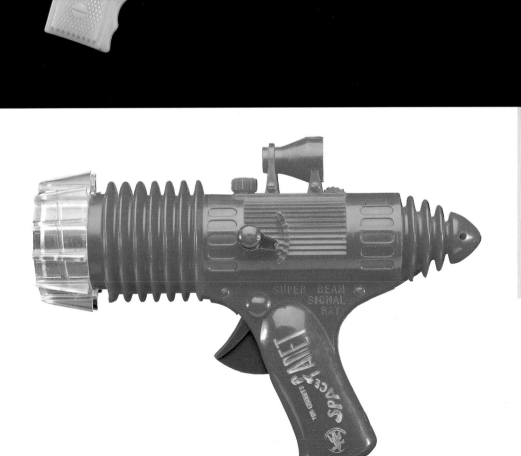

Space Navigator wrist
compass and badge;
marked W.S.N.Y.
1950s

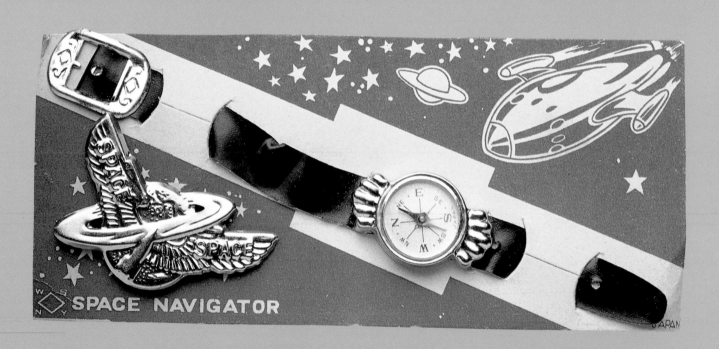

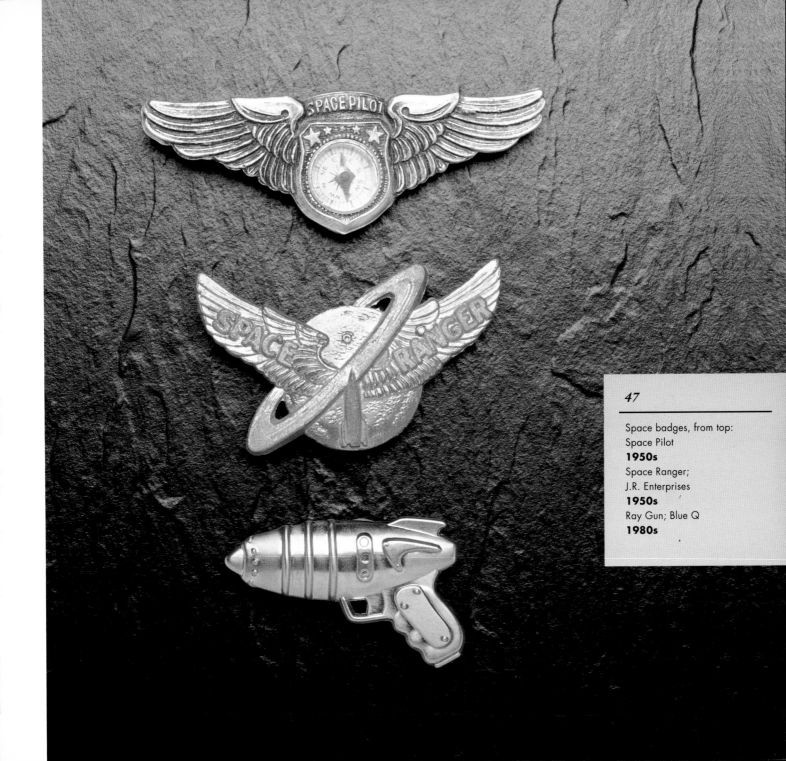

47

Space badges, from top:
Space Pilot
1950s
Space Ranger;
J.R. Enterprises
1950s
Ray Gun; Blue Q
1980s

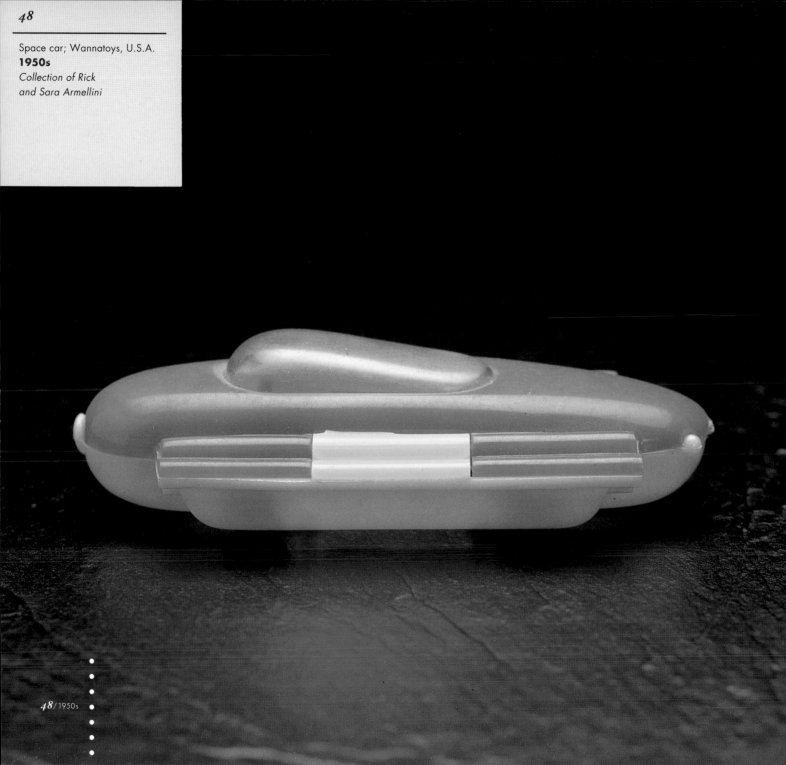

Space car; Wannatoys, U.S.A.
1950s
*Collection of Rick
and Sara Armellini*

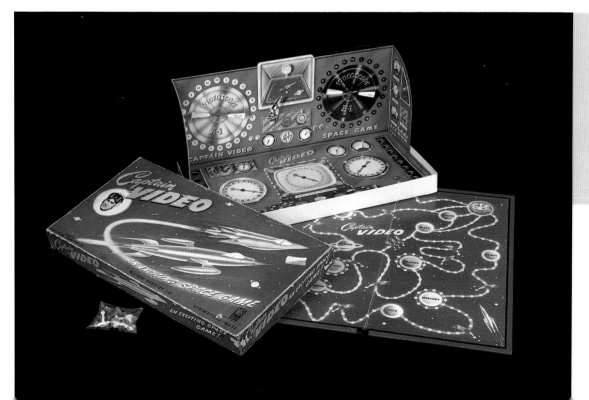

50

Captain Video Space Game;
Milton Bradley Co.,
Springfield, MA
1950s

49/1950s

Tom Corbett box
1950s

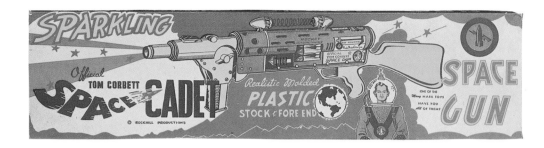

Tom Corbett Flashlight Pistol;
Marx, New York, NY
1950s
Shown with Tom Corbett thermos;
Aladden Industries,
Nashville, TN
1950s
Collection of Tom E. Tumbusch.

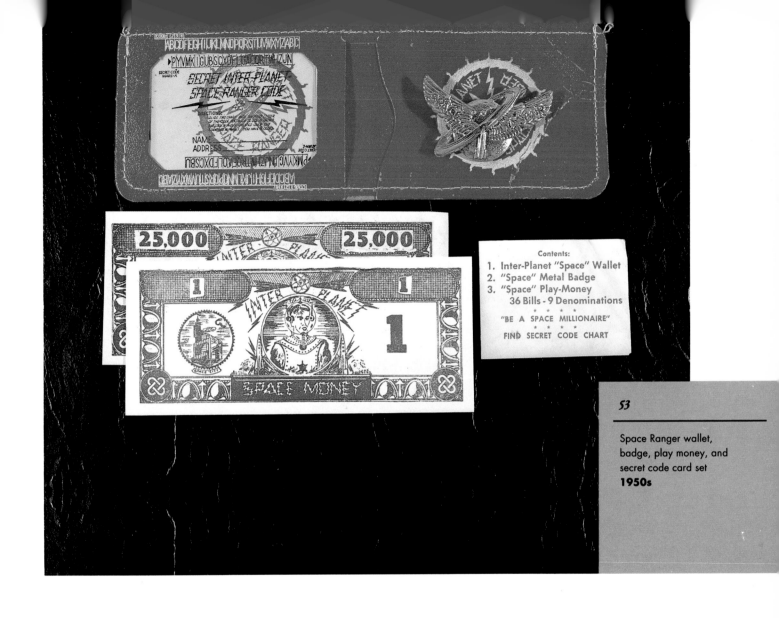

Contents:
1. Inter-Planet "Space" Wallet
2. "Space" Metal Badge
3. "Space" Play-Money
 36 Bills - 9 Denominations
* * * *
"BE A SPACE MILLIONAIRE"
* * * *
FIND SECRET CODE CHART

53

Space Ranger wallet,
badge, play money, and
secret code card set
1950s

Captain Video Secret Ray
Gun; Power House candy
bar premium
1950s
*Collection of Norm
and Cathy Vigue*

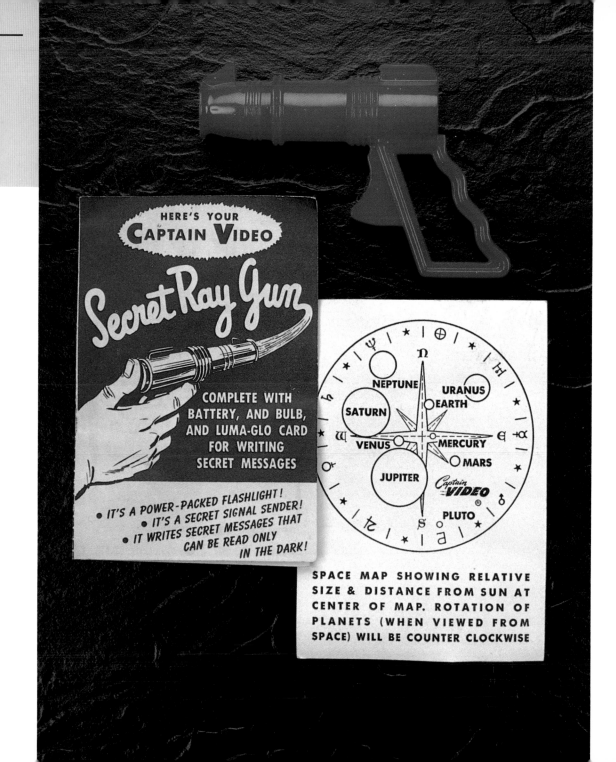

HERE'S YOUR
CAPTAIN VIDEO

Secret Ray Gun

COMPLETE WITH
BATTERY, AND BULB,
AND LUMA-GLO CARD
FOR WRITING
SECRET MESSAGES

- IT'S A POWER-PACKED FLASHLIGHT!
- IT'S A SECRET SIGNAL SENDER!
- IT WRITES SECRET MESSAGES THAT
 CAN BE READ ONLY
 IN THE DARK!

NEPTUNE URANUS
SATURN EARTH
VENUS MERCURY
JUPITER MARS
 PLUTO

Captain VIDEO

SPACE MAP SHOWING RELATIVE
SIZE & DISTANCE FROM SUN AT
CENTER OF MAP. ROTATION OF
PLANETS (WHEN VIEWED FROM
SPACE) WILL BE COUNTER CLOCKWISE

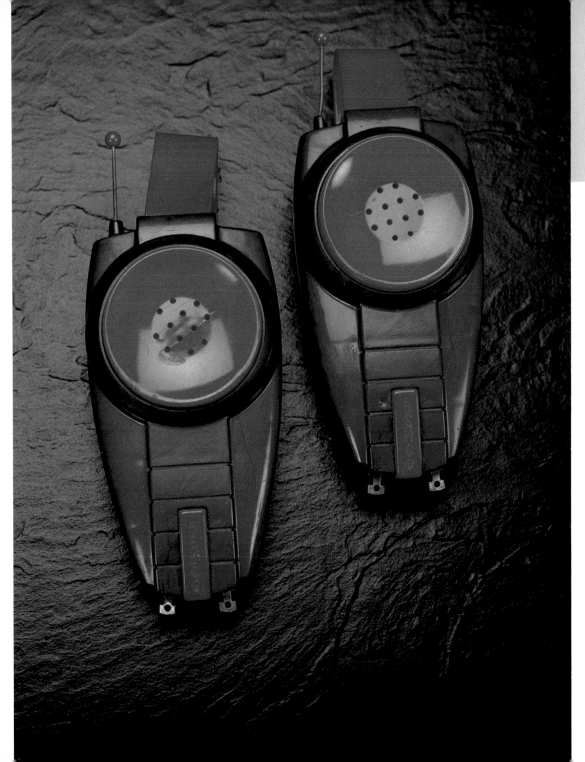

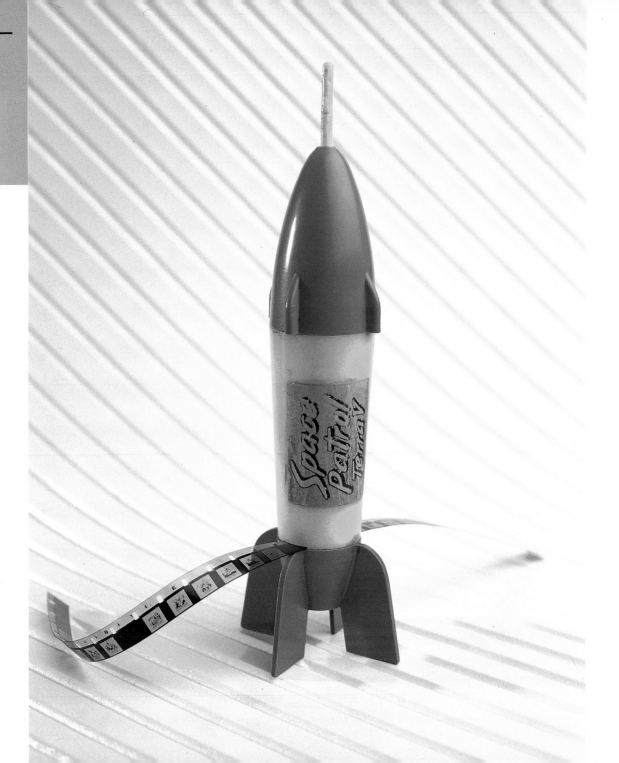

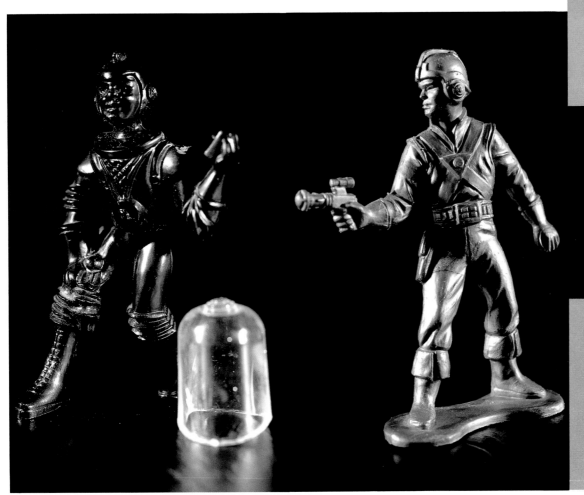

59

Key chain figure
1950s

60

Tom Corbett
Parallo-Ray ring;
Kellogg's cereal
premium
1950s

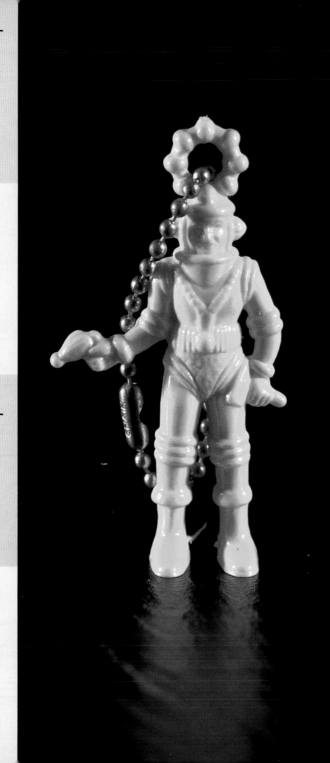

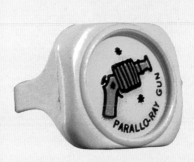

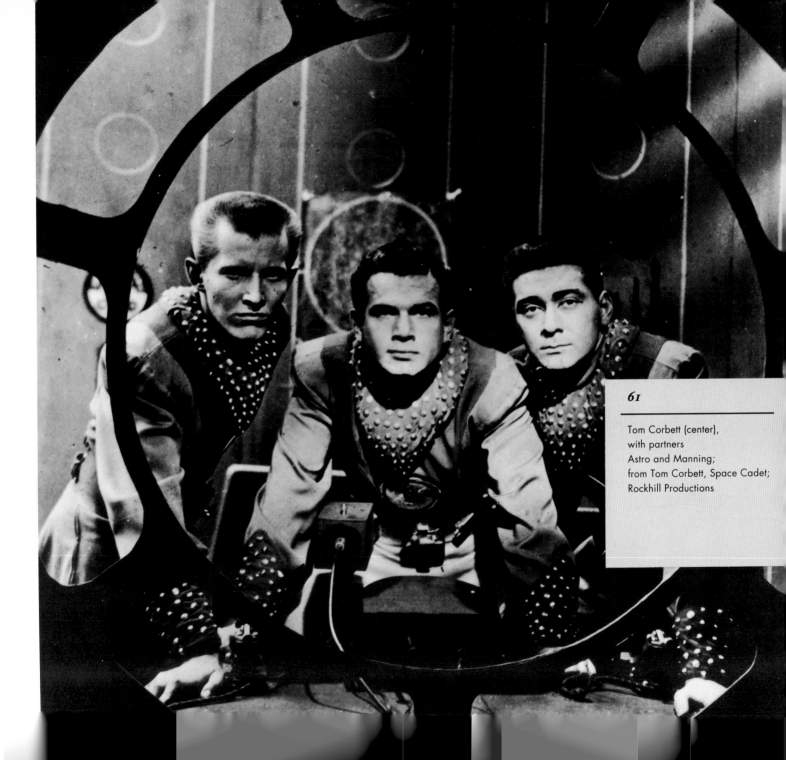

61

Tom Corbett (center),
with partners
Astro and Manning;
from Tom Corbett, Space Cadet;
Rockhill Productions

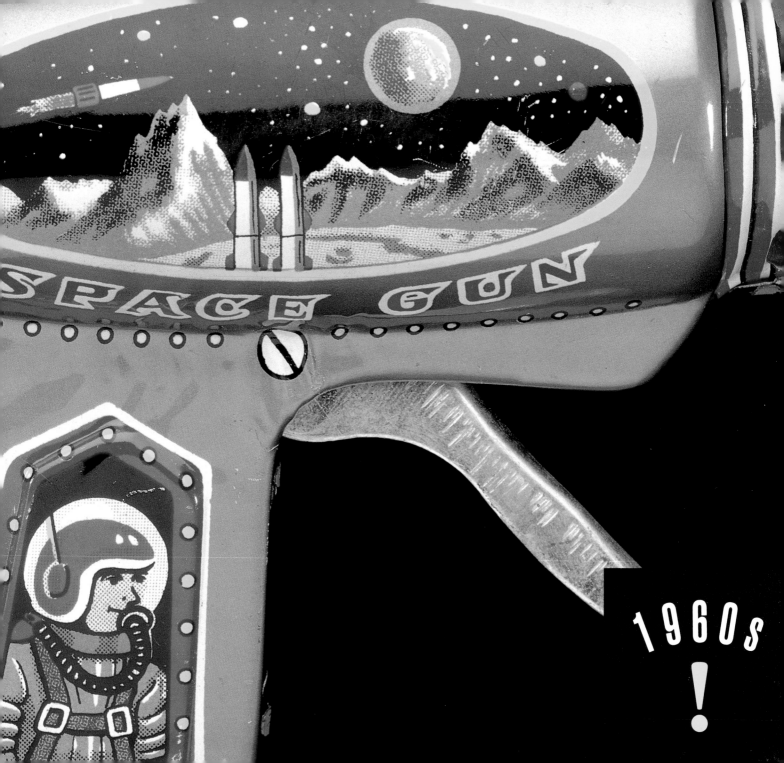

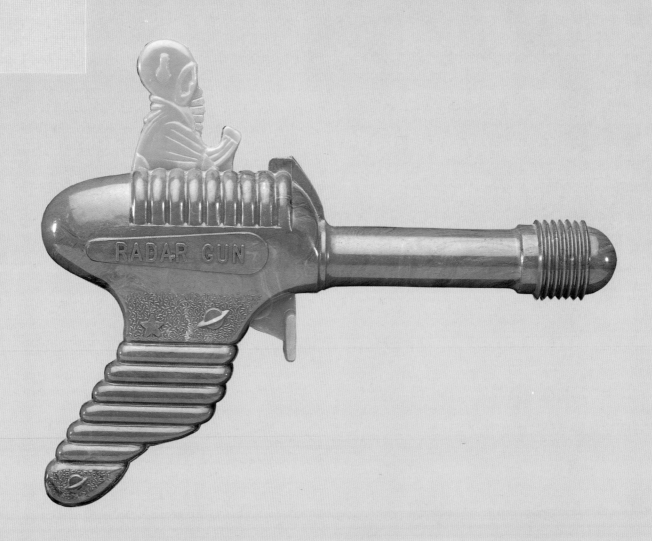

64

Strato cap gun; no markings
1950s-60s

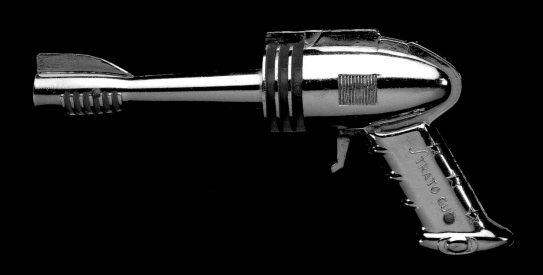

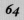

Flash X-1; Shudo, Japan
1950s-60s
*Collection of Rick
and Sara Armellini*

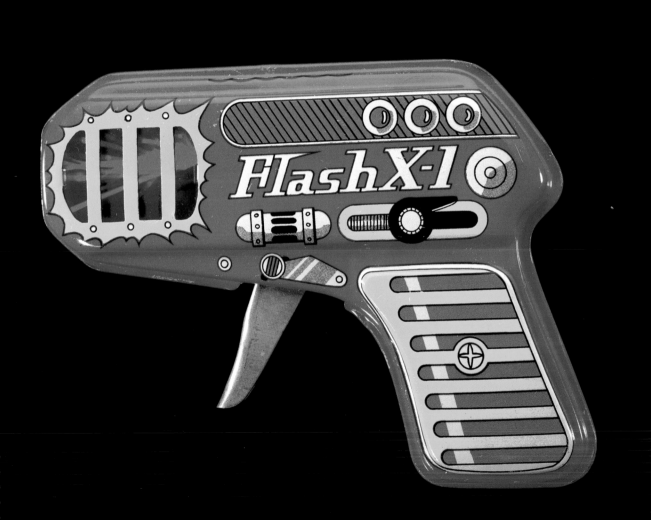

Water pistol; no markings
1950s-60s
*Collection of Rick
and Sara Armellini*

67

Water pistol; Park Plastics,
U.S.A.
1950s-60s
*Collection of Rick
and Sara Armellini*

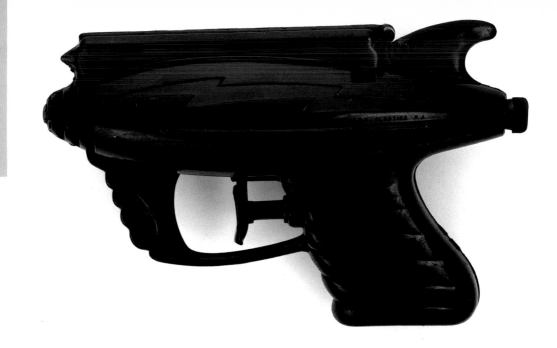

68

Water pistol; Palmer
Mfg., U.S.A.
1950s-60s
*Collection of Rick
and Sara Armellini*

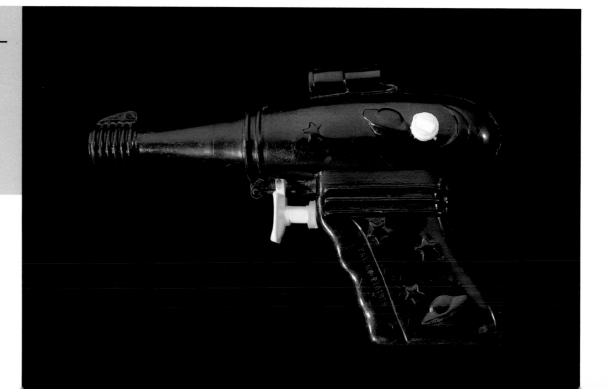

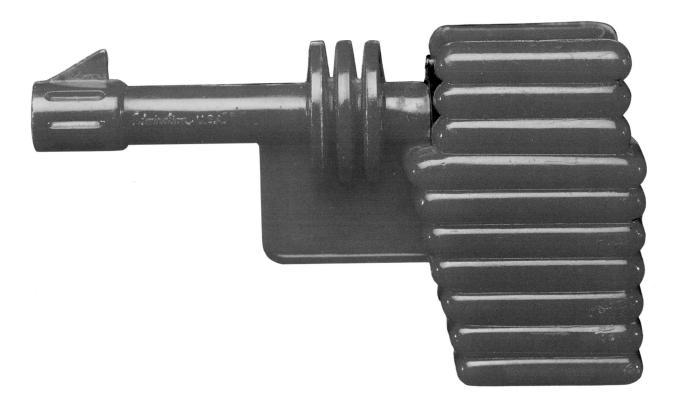

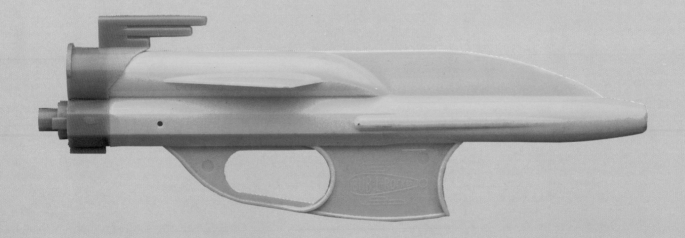

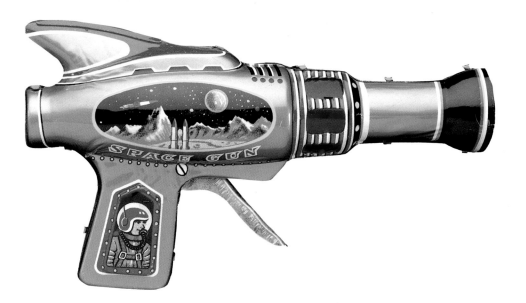

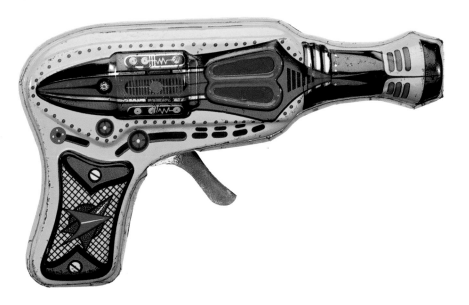

72

Sparker;
Toy Hero Co., Japan
1960s

MADE IN HONG KONG

1970s

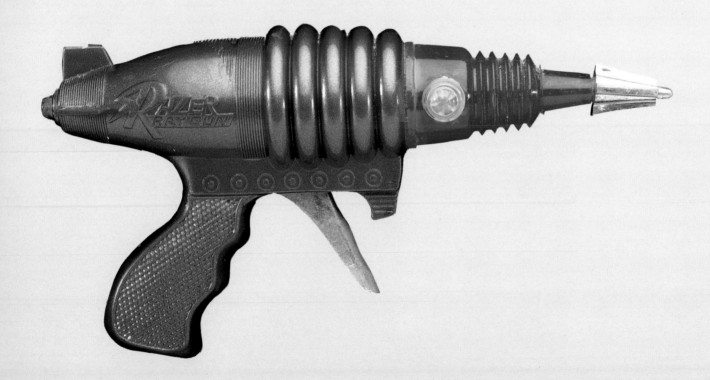

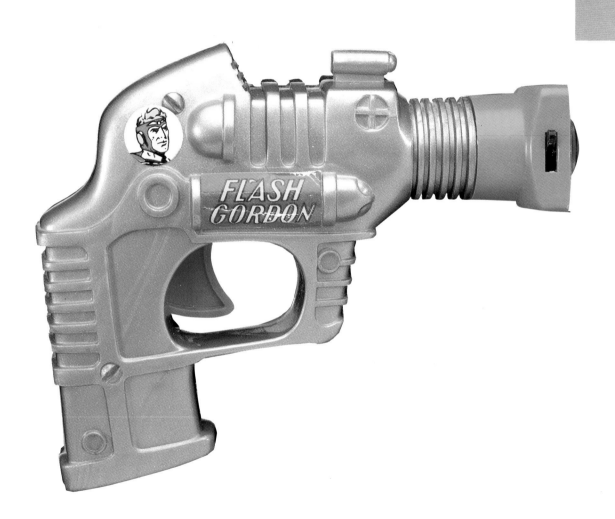

75

Sparking Space Gun;
MF 227, China
1970s

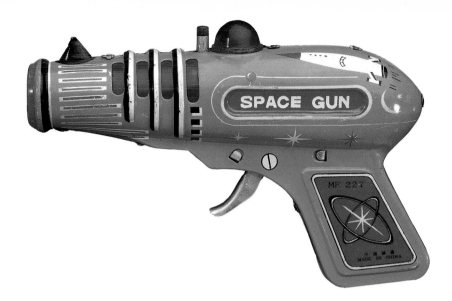

76

Astro Ray Gun;
Shudo, Japan
1970s

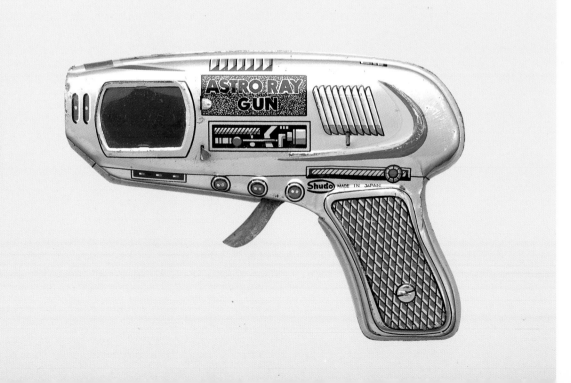

Han Solo Laser Pistol;
Kenner Products,
Cincinnatti, OH
1978

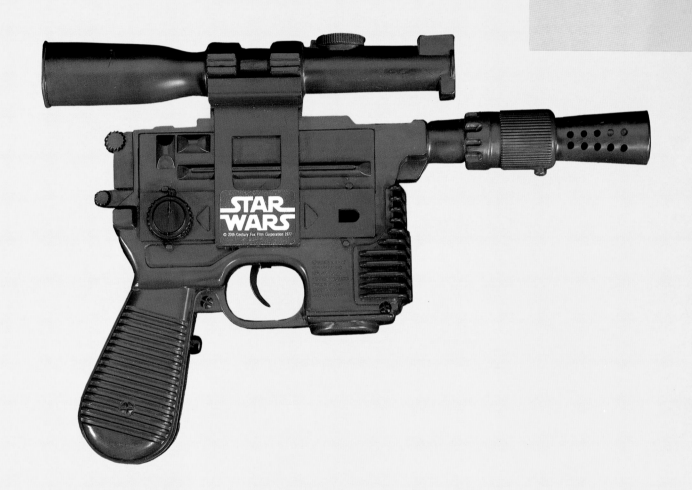

Space Gun; MTU,
Korea
1970s

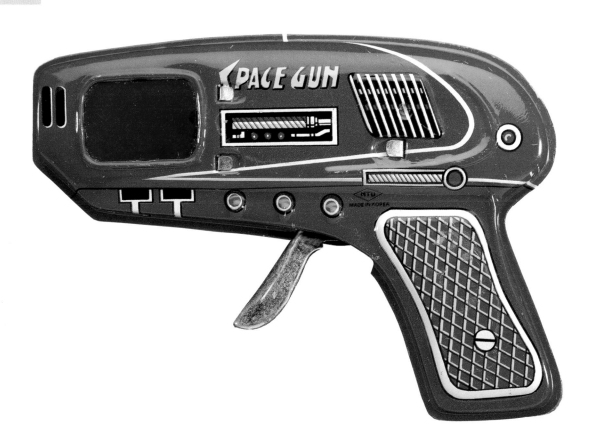

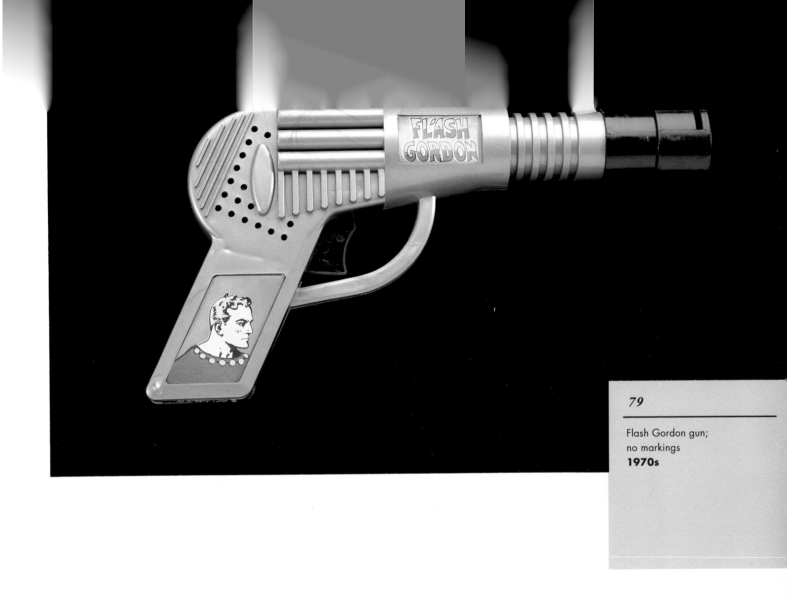

79

Flash Gordon gun;
no markings
1970s

Articulated metal robot
1970s

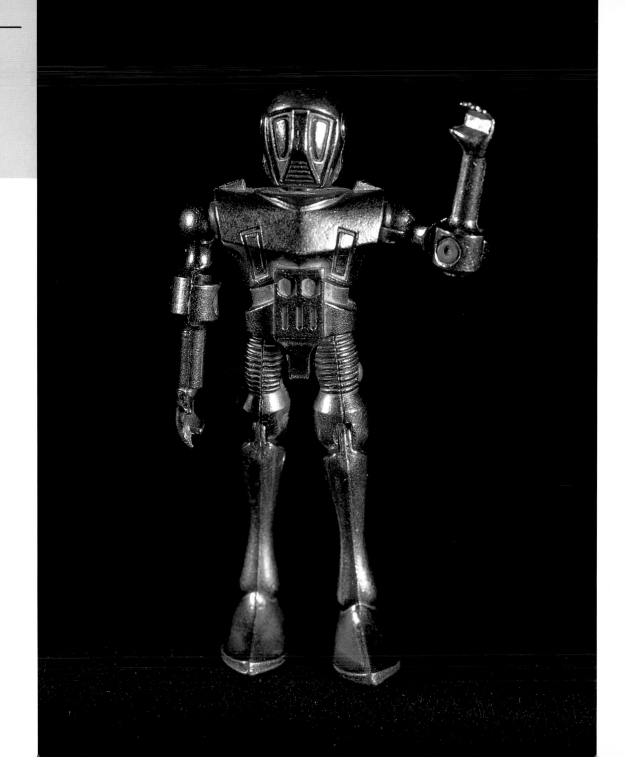

Bat-Ray Projection
Pistol; Remco,
Newark, NJ
1977

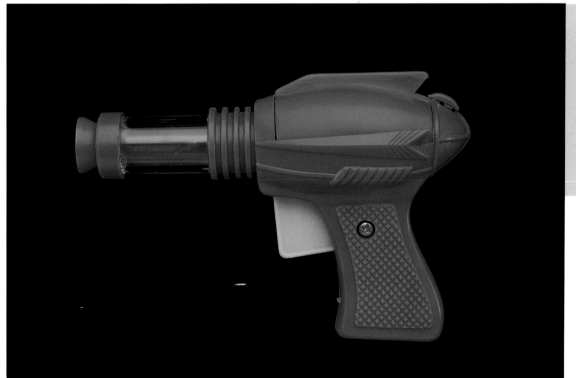

82

Blue Laser; Azrak-Hamway
International, Inc.,
Hong Kong
1978

Shining light gun;
Vanity Fair Industries, U.S.A.
1978
Collection of Rick and
Sara Armellini

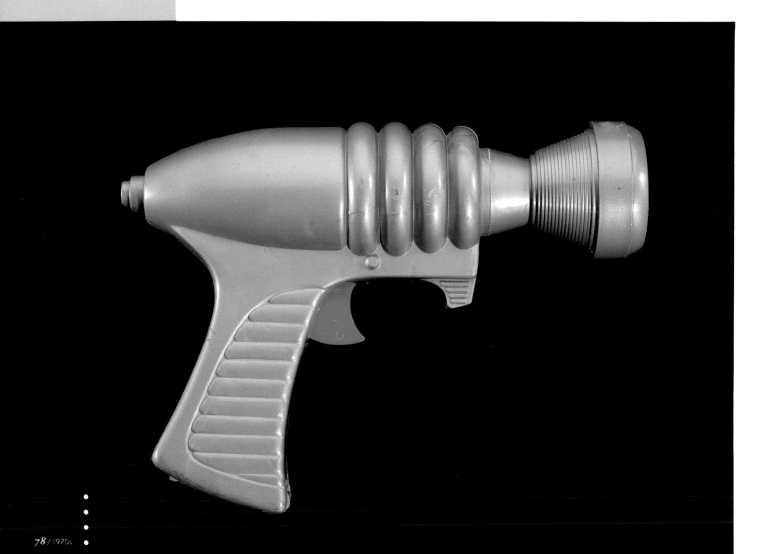

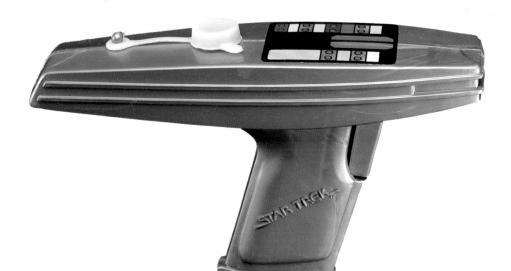

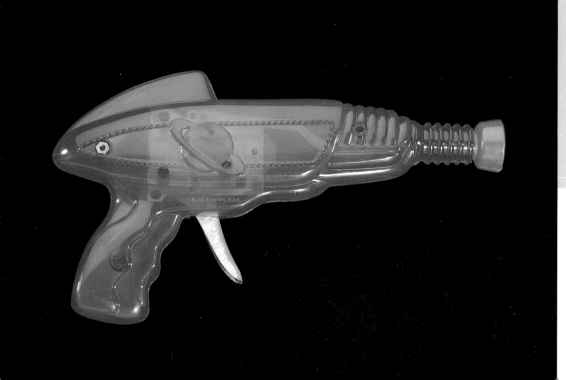

85

Blue sparker;
Hong Kong
1970s-80s

1980s

86

Potato plug shooter;
Hong Kong
1980s

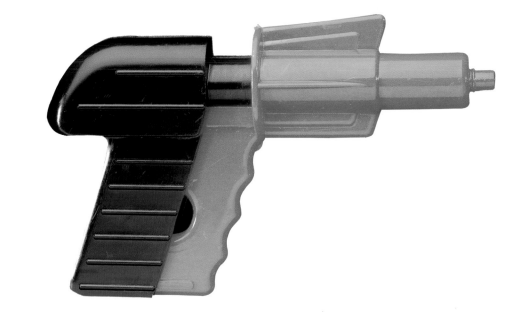

87

Laser barrel;
Azrak-Hamway International,
Inc., Hong Kong
1980s

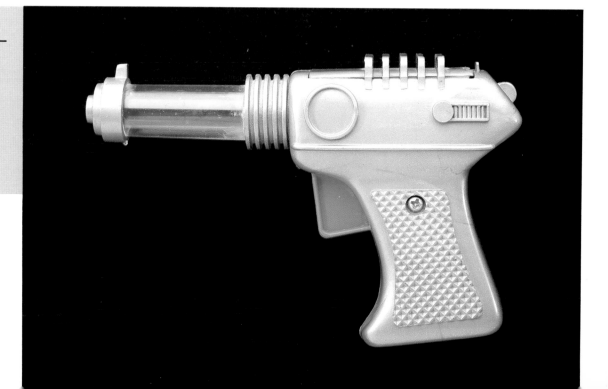

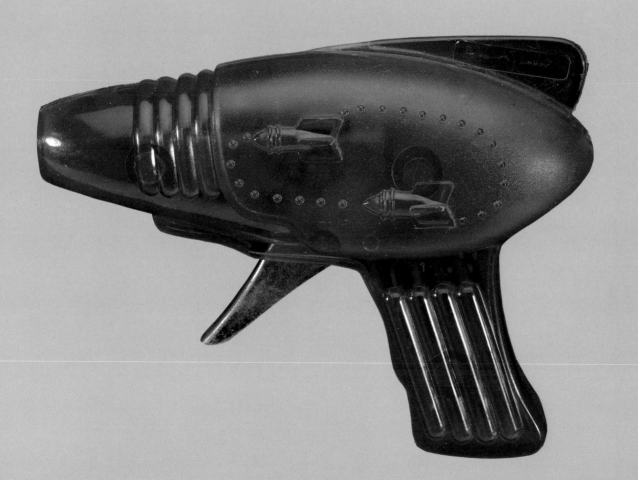

89

Sparking gun;
WF, Hong Kong
1980s

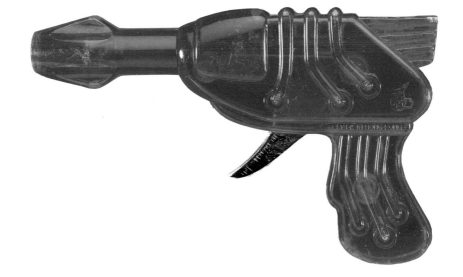

90

Soft water gun;
no markings
1980s
*Appears to be copied from
a mold of the hard plastic 1950s
Flash Gordon gun by Marx.*

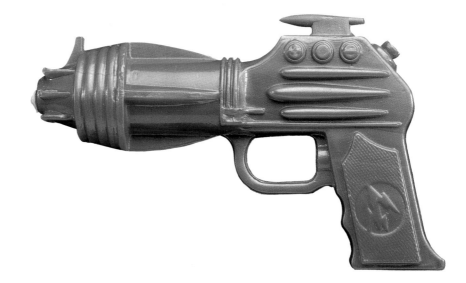

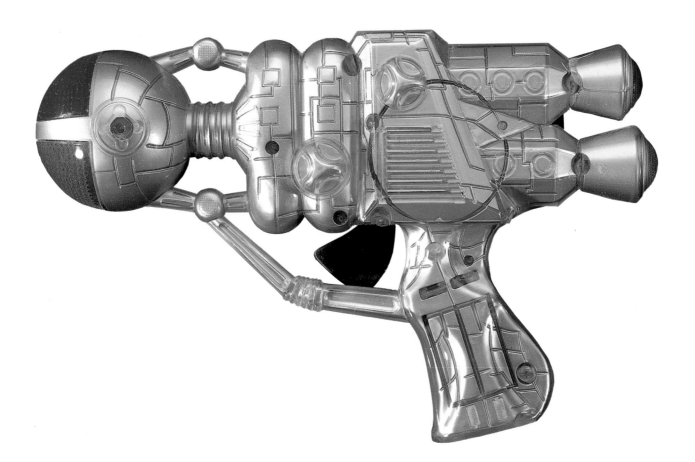

92

Multisound and light
space gun; no markings
1980s

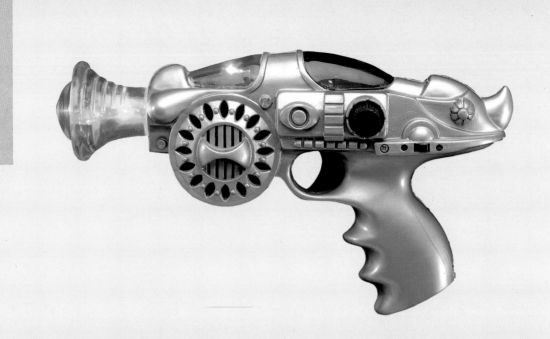

93

Astroray Gun;
Shudo, Japan
1980s

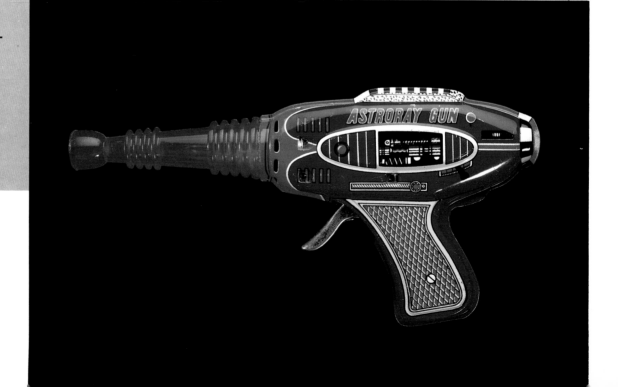

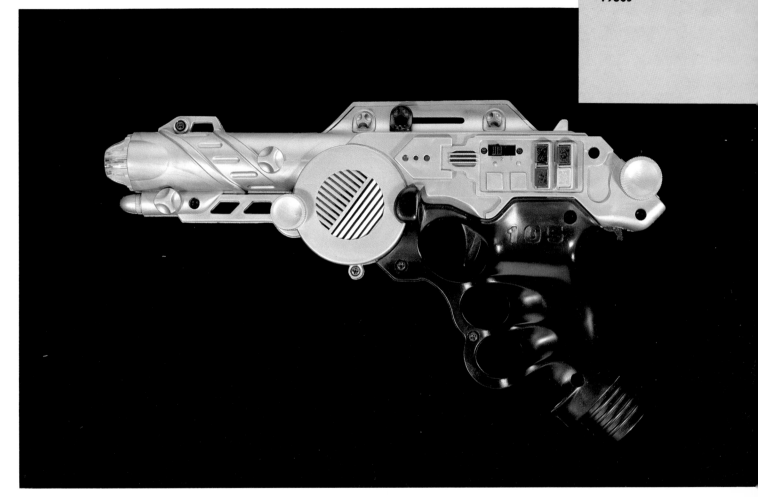

Ray rifle;
China
1980s

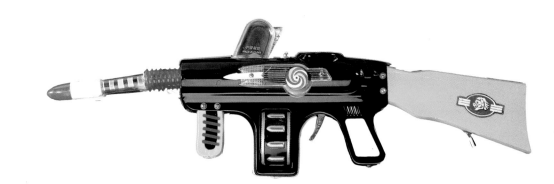

White ray gun;
Radio Shack,
U.S.A.
1980s
*Collection of Carolyn
Armstrong*

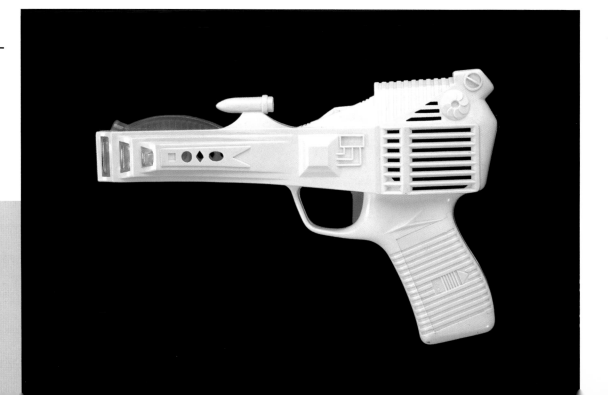

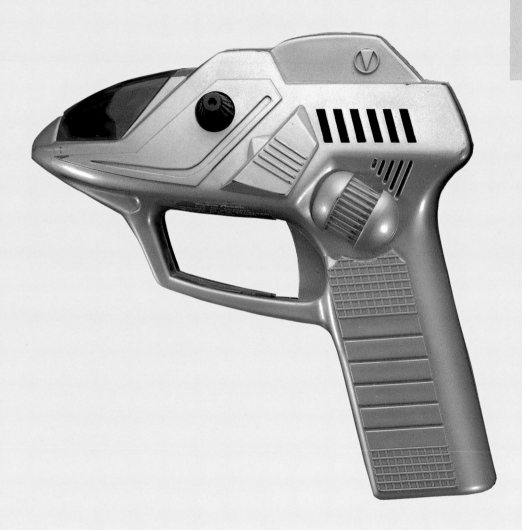

Hake, Ted. *Hake's Guide to TV Collectibles.*
 Radnor, PA: Wallace-Homestead Book Co., Division of Chilton Books, 1990.

Lesser, Robert. *A Celebration of Comic Art and Memorabilia.*
 New York, NY: Hawthorn Books, 1974.

Longest, David. *Character Toys and Collectibles.*
 Paducah, KY: Collector Books, 1984.

Payton, Crystal, and Payton, Leland. *Space Toys: A Collector's Guide
 to Science Fiction and Astronautical Toys.*
 Sedalia, MO: Collectors Compass, 1982.

Sansweet, Stephen J. *Science Fiction Toys & Models.*
 New York, NY: Starlog Press, 1980.

Tumbusch, T. N. *Space Adventure Collectibles.*
 Dayton, OH: Tomart Publications, 1990.

Tumbusch, Tom E. *Illustrated Radio Premium Catalog and Price Guide.*
 Dayton, OH: Tomart Publications, 1989.

Magazines and Catalogs for the Collector:

Antique Toy World; P.O. Box 34509, Chicago, IL 60634

Collector's Showcase; P.O. Box 271369, Escondido, CA 92027

Hake's Americana & Collectibles; P.O. Box 1444, York, PA 17405

The Toy Shop; 700 E. State St., Iola, WI 54990

PHOTO# NAME PRICE RANGE

2 Rocket Signal Pistol $75-250

3 Atom Ray Gun $200-450

4 Buck Rogers cast-iron rocket $40-100

5 Lead figures: spacemen $5-20 ea.
cast-iron Buck Rogers space ship $40-100

6 Buck Rogers Rocket Pistol $100-200

7 Pop Ray $75-125

8 Buck Rogers XZ-44
Liquid Helium Water Pistol $100-300

9 Buck Rogers XZ-38
Disintegrator Pistol $100-125

10 Buck Rogers ad card $75-150

11 Nu-Matic paper popper $25-75

12 "Buck Rogers" Sunday funnies $50-100

13 *Buck Rogers in the War
with the Planet Venus* $20-50

14 Daisy Zooka Pop $50-100

15 Paper popper $25-75

16 Flash Gordon Air-Ray Blaster $100-250

17 Rocket Dart Pistol $75-125

18 Atomic Disintegrator
repeating cap pistol $100-300

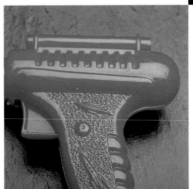

19 Atom Bubble Gun $75-150

20 Smoke Ring Gun $100-300

23 Space Control $25-50

24 Tom Corbett Click Pistol $100-250

25 Atomic Space Gun $25-75

27 Space Patrol Rocket Gun $150-400

28 Atomic Flash $25-75

29 Tom Corbett Push-Out Book $100-150

30 Space Patrol Cosmic Smoke Gun $100-300

31 Red clicker $25-50

33 Red water pistol $10-20

34 3-Color Space Ray $100-200

35 Rex Mars Planet Patrol
Sparking Pistol $50-150

36 Sonic Squirt $10-25

37 Rocket Gun $50-125

38 Tomi gun $25-75

39 Planet Jet $25-50

40 Tom Corbett Atomic Rifle $150-300

41 Official Tom Corbett Space
Gun rifle $150-300

42 Flash Gordon Click Ray Pistol $200-450

43 Space Patrol Atomic
Pistol Flashlight $150-300

44 Buck Rogers Super Sonic Ray $75-200

45 Tom Corbett Atomic Pistol $100-300

46 Space Navigator wrist compass $25-50

47 Space badges, from top:

Space Pilot $35-60
Space Ranger $35-50
Ray Gun $10-15

48 Space car $20-30

50 Captain Video Space Game $40-75

52 Tom Corbett Flashlight Pistol $125-225
and Tom Corbett thermos $35-60

53 Space Ranger wallet,
badge, play money, and
secret code card set $50-75

54 Captain Video Secret Ray Gun $50-100

55 QX-2 Walkie Talkies $75-150

56 Space Patrol Terra V
Project-O-Scope, with film $250-500

57 Character with helmet $15-20

58 Plastic character $10-20

59 Key chain figure $10-25

60 Tom Corbett Parrallo-Ray ring $8-20

62 Radar Gun $15-20

63 Whistle gun $15-20

64 Strato cap gun $100-200

65 Flash X-1 $20-30

66 Water pistol $15-25

67 Water pistol $15-25

68 Water pistol $15-25

69 Pencil sharpener ray gun $5-15

70 Bub·L· Rocket $20-50

71 Super Sonic Space Gun $15-20

72 Sparker $10-20

73 Razer Ray Gun $5-10

74 Flash Gordon Click Light $15-20

75 Sparking Space Gun $10-20

76 Astro Ray Gun $10-20

77 Han Solo Laser Pistol $25-40

78 Space Gun $5-10

79 Flash Gordon gun $10-20

80 Articulated metal robot $25-50

81 Bat-Ray Projection Pistol $25-50

82 Blue Laser $10-20

83 Shining light gun $10-25

84 Star Trek water pistol $15-25

85 Blue sparker $5-15

86 Potato plug shooter $5-10

87 Laser barrel $10-20

88 Blueray gun $1-3

89 Sparking gun $5-10

90 Soft water gun $5-10

91 Multisound ray gun $10-20

92 Multisound and light space gun $10-20

93 Astroray Gun $10-25

94 TG-105 $10-25

95 Ray rifle $25-75

96 White ray gun $5-10

97 Silver ray gun $5-10

BACK FLAP

Rocket Space Police Patrol
propeller beanie $45-65
and Captain Video space helmet
$75-100